This Coloring Book Belongs To:

A COLORING BOOK CREATION BY
ORIGINALCOLORINGPAGES.COM

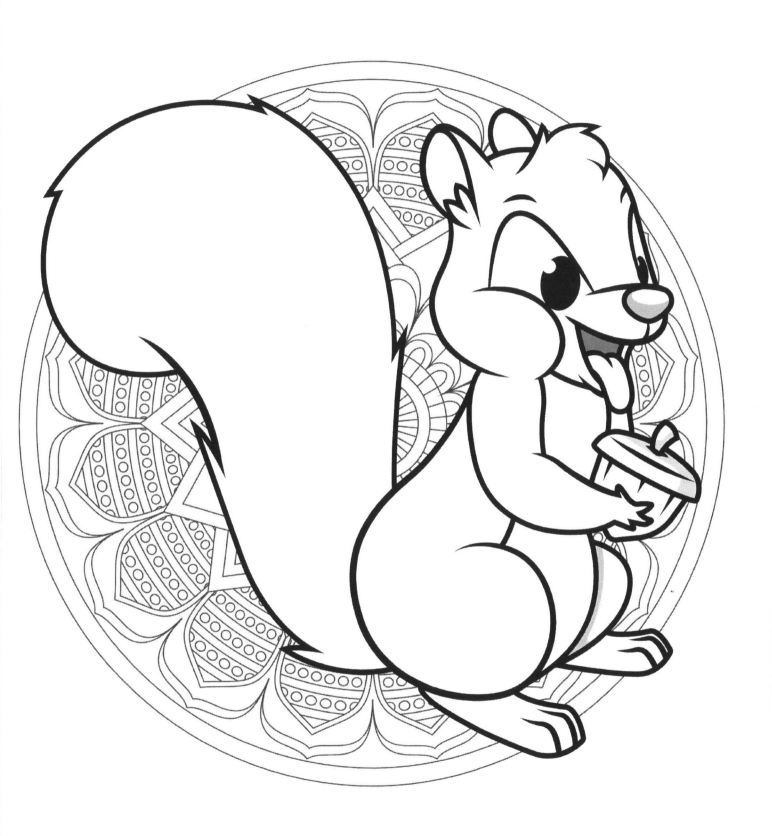

ORIGINAL COLORING Pages.com

Thanks for the coloring!

Don't Forget to Leave Us
a Review on Amazon!

A COLORING BOOK CREATION BY
ORIGINALCOLORINGPAGES.COM

Made in the USA
San Bernardino, CA
07 December 2019

61047530R00033